BLUE CHIP

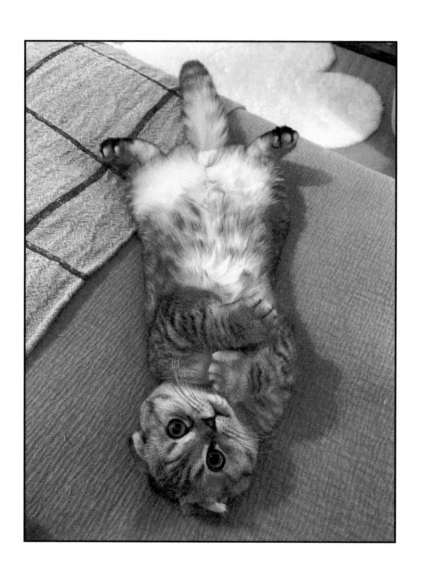

BLUE CHIP

CONFESSIONS OF
CLAUDIA SCHIFFER'S CAT

gestalten

"I've always been famous,
it's just no one knew it yet."

LADY GAGA

"Strange that we have to
make these public declarations
of our secrets. But we do."

TED HUGHES

AMALFI COAST, ITALY, 2022

My darlings,

I hope you're sitting comfortably. The day has finally arrived. I've put paw to paper to share my life with you. Some itches simply have to be scratched. There comes a time in any cat's life when there is more behind them than there is in front of them. But of late the facts of my life have become something of a fiction, a plaything for tabloid hacks and Twitter vigilantes.

If you want to get ahead in showbiz – then you need to get ahead of the narrative. So rather than be lowered into the rumour mill (along with the recycling), I'm climbing into the literary canon with grace and poise. As a diarist, I'm in the finest of company; Samuel Pepys, Virginia Woolf, Bridget Jones and me. They say a cat has nine lives, but I've lived that nine times over. So, I have decided to bare all and show you how the other half really do live. Plus, my publisher's advance was hard to refuse…

For those who don't know who I am (do you live under a
rock?), it might appear that my life is one king-sized bed of
roses, that my fame and fortune came from being born with
a silver spoon in my mouth. But that couldn't be further
from the truth; it was actually porcelain. When Claudia
(yes, you heard that right, *the* Claudia Schiffer) plucked me
out from the litter, that wasn't luck – it was Fate's gentle
hand on the tiller of life, steering me on course to stardom.
But that journey has been far from plain sailing…

It is rather annoying when your only claim to fame is being Claudia Schiffer's cat. This is my story, of how a supernova feline finally escapes a Supermodel's shadow.

Of course, everything in the following pages is true, apart from the things I have completely made up.

Yours,

CHIP

Bonjour mes chéris,

They say you never forget your first Cannes. It's true but by day number six it's only natural that the gloss begins to lose its sheen; the Riviera doesn't sparkle in quite the same way, and my patience for world cinema is running a tad thin… Forgive me, I'm being somewhat sour. Just heard I didn't get the part for *Lady and the Tramp 2*, feeling rather fragile… Claudia's negotiating what to wear to a premiere tonight and so I haven't been stroked since the chap from concierge dropped off a bouquet and bottle of Dom. I could have sworn I asked the bellboy to bring me some sardines but that must have got lost in translation. Rejection on a hangover – name a more wretched cocktail?

Claudia's returned and she looks a vision, as always. She's gone with Celine. I could have told her that seven outfits ago, but I've learned to keep schtum on days like today if I want to be tickled. The biggest win is that her dress compliments my summer coat. Louis Vuitton have kindly fashioned a rather chic Moses basket for Claudia to carry me up the carpet in. Oh, please, you really thought I was going to walk? Our chauffeur has finally decided to arrive, so it's time to set down the pen, don these Prada shades and give the world what they've come to see – *moi*. Big smiles now…

Blissful to be back in the sanctuary that is home. The kids are unsuccessful in their attempts to lure me to the pool. How many times do I have to tell them this cat doesn't go swimming? Rolled over and managed to snatch another few hours shut-eye. I emerge just before elevenses to find the fattest cat of the West End sitting at the kitchen table. I stop in my tracks. I can't resist a good musical – who can? They're my Achilles paw. I gather myself, and hurdle the chaise-longue, humming 'Memories' as I skip onto the kitchen island and come to a graceful halt atop a case of 1994 Chablis. You could see the applause in his eyes. Lovely to snuggle up with a fellow connoisseur, his double cashmere cardigan is perfect networking knitwear. He is talking about *Cats* (of course) and I'm sure he has just alluded to an open role.

This could be my big chance! I shall remain cool, but there's no harm in a quick WhatsApp to my agent… I hear plans to re-launch his feline masterpiece: first in the West End, a quick transfer to Broadway followed by a global tour. My whiskers twitch, I've never been to Sydney in Spring…

We're up early to enjoy the spoils of Daylesford, our local farmers market, which is never not a treat. Past experience has taught us it's best to leave Smartie* at home for these charmed excursions, as she simply can't control herself around organic produce. God's garden was in full flow: sourdough, baguettes, figs and ferments assault the senses, and I just want to churn their cheeses into an unruly lather. As promised, Claudia got me a little treat from the monger; two Dover sole fillets with a sprinkling of saffron and dill. It would be terrible if this news somehow made its way back to Smartie…

No word from the casting agent re: the musical.
No need for concern quite yet.
Slowly slowly catchy mousey…

* Smartie is the other cat who I share my life with. She's a largely forgettable creature, a literal footnote in the tapestry of my life.

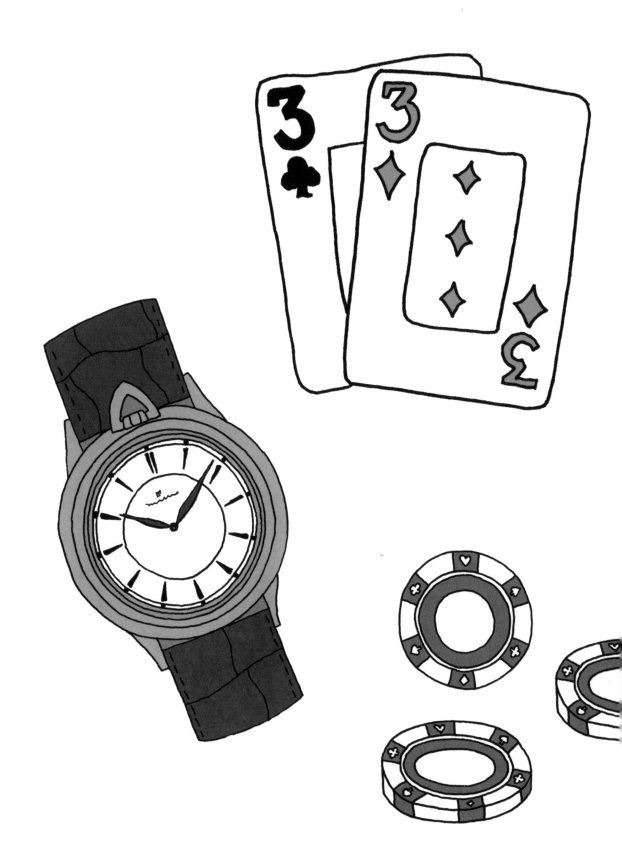

25 JULY

t's Poker Night at home and I'm all in. You wouldn't know it to look at me, but I'm quite the card shark. I'm sworn off whiskey and cigars these days, but put a salmon terrine on the table and I'll bet the house. Rollo* has decided to make an appearance, hulking at the door. He is always a favourite at these events, probably because he is big and he barks and looks like he should be keeping guard at an East End crack den. Where is a muzzle when you need one...

I have to suppress a titter as my opponent loses his watch to a pair of threes.

* Rollo is a German shepherd who prowls around the house like he owns the place, which couldn't be further from the truth. He's toxic masculinity on four paws and thick as two short ones. Don't worry, he's not going to read this, he can't even read.

30 AUGUST

Fashion season is upon us and the runway beckons. We'll be across the pond for a couple of weeks. I'd be lying if I said I wasn't looking forward to it, but I'm riddled with the anxieties of any actor worth their salt – what happens if I get a callback when I'm away? What if I'm too late to a script? It would be just my luck... I've told my agent to call if anything comes through. They'll fly me home if needs be... Oh, but looking at the sketches Ralph Lauren have sent us, I couldn't miss this show for the world...

6 SEPTEMBER, NEW YORK

As the newlyweds in the suite next door insist on reminding me, New York is the city that never sleeps. Now while that may be true, I have news for this city – this cat doesn't do anything without nine hours kip. I've made my position very clear to Claudia; I'm not hitting the runway until noon, and if that means I miss the shows; it means they miss me. Fashion Week, you can never please everyone...

Some highlights so far: The Row was out of this world; so sleek, so chic. I don't know which was harder, quitting smoking or resisting the urge to reach out and tug at those baubles as they trotted by… Anna Sui was remarkable; dazzling, electric, effervescent, all the synonyms… and it was heavenly catching up with the creative team over sushi when all the fanfare had died down (as much as it ever can in this town). Some shows I'm not dishing the dirt on yet, but what I can say is that whatever they're putting in the pisco sours this year needs to be taken out: this is Fashion Week, not a guided tour of Willy Wonka's sweet shop. Come on people!

8 SEPTEMBER

We have front row seats to the Marc Jacobs show tonight. They asked me to walk but I didn't want to intrude on Claudia's turf, some lines aren't worth crossing. No, I'll be sat in my usual seat, my R.B.F. at the ready. Right, I suppose it's time to face the day. I stretch my legs. The city holds its breath…

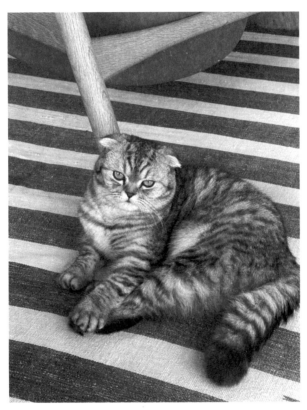

You talkin' to me?

As luck would have it, we've arrived home and what's waiting for me (besides Smartie's cold shoulder) but an audition! (Smartie can't stand the fact that I am a casting director's dream.) It's what they call an 'open audition', but they just say that to be inclusive – they know who they want. I pour myself a saucer of Gold Top milk and settle into my reading nook in the drawing room with the audition notes. Right, where are my glasses?

It's a wizard franchise, based on those books the kids go wild for. Beasts being fantastic, or something. Well, who would be more fantastic than *moi*? They know where to find me; I'll be at my private members' club with a passion fruit martini in hand. I jest, the pay is not to be sniffed at, and Claudia's kids would love me to be involved. I'll throw my tail into the ring. Who knows, the films might take off...

Dear applicant,

Thank you for auditioning for the part of
Cat 1 or 2. We have received your audition
tape and will be in touch shortly.

Best wishes,

█████████

Casting Director

Dear applicant,

Thank you for auditioning for the part of Cat 1 or 2.
We very much enjoyed your 'committed' performance,
particularly your rendition of Frank Sinatra's
'My Way'. Unfortunately, we did not think you were
quite suitable for the role and as such we will not
be moving forward with you on this occasion.

Best wishes,

█████████

Casting Director

Feeling rather bruised by that rejection if truth be told. And while you can't lick your wounds forever, they are tasty for that first 48 hours.

Claudia has been full of understanding, lots of cuddles and caviar. She says all the right things; that it's their loss, that a new part will come along, that I was too good looking for the role. She's right, I may be fantastic but I'm no beast. We go again. Onwards and upwards…

TINKLE, TINKLE LITTLE STAR!

Claudia's birthday is a way off, but the family and I want to get her something rather special, something lasting. I've settled on the idea – it will be a sculpture of me for the garden. The artist cycled over this morning to make some preliminary sketches – how they cycled wearing that dress and platforms, I'll never know. The brief: Rodin's *Thinker*, but sassy. Artists really are the most wonderful company; we spent a very happy morning comparing notes from the Venice Biennale – at least what we can remember from it. But the real star of the show was the artist's cat, Kevin, who is straight out of art school and as cool as they come. He had no time for Smartie, which means he went straight into my good books. Whisker it quietly – I think Kevin is my new best friend!

Aboard the red-eye again. Surely it's only a matter of time before I crack America? I've got enough airmiles to show for it…

Touched down in JFK and checked into The Greenwich. That night we headed to Midtown for the exclusive book launch of Grace's memoir – a woman who always leaves me feline fabulous. Everyone who was anyone was there. She gave a reading and sat for signings with me perched upon her lap.

With so many stars to see, it was just my luck to get caught in a more than dry exchange between two Irish authors who were debating the moral merits of memoir (yawn). Whatever happened to having a good old conversation with friends… Would have *loved* to have stayed and chatted, but we had a late night reservation at a new joint in Brooklyn with the author and her editor, who was desperate to know when I was putting paw to paper. All in good time. All in good time…

The animal rich list was published today and Forbes have left me out! So unlike them... I called my bank manager straight away. Now I don't want to come across as a crass old cat, but facts are facts and I've more spare change in my piggy bank than some of these creatures. Taylor's little darlings are a new entry at number four – no surprises, that's what happens when you invest well. I am convinced they are distant cousins of mine, obviously good sense is in the DNA. And talking of investments, I can see Gunther IV is still at number one: the German shepherd who inherited his lot and lives off the interest. Rollo is green with envy, but he mustn't get any ideas; I've seen the will, and I know which pet Claudia is leaving everything to...

8 FEBRUARY

I haven't had an audition in months, and I'm starting to feel a little twitchy. Perhaps it's time for some new headshots. Yes, that might be just the ticket. I've really grown into my looks of late: I've shed some of that kitten fat which was, although charming, not quite selling me as the lean, mean acting machine I am today. I'll make a few calls, see who has some time to snap away at me...

Flicking through some old photos of me as a kitten – it's fair to say that, cute though I was, it wasn't obvious to everyone that I was the litter queen. Take a look for yourself – I know, right – how could you say no to those eyes, but plenty of casting directors did! It's so funny, looking back on life, the press are so quick to assume that it all came so easy, but that couldn't be further from the truth. I was a shy kitty cat, a quivering wreck of whiskers and paws… but then of course puberty hit and like Katy Perry, I found my roar!

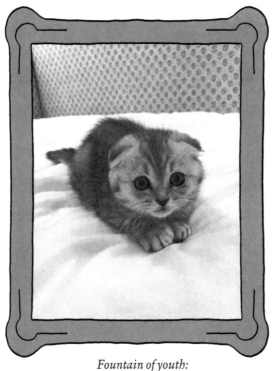

Fountain of youth:
I really was a darling.

Aday at Sotheby's. Bliss. The Picasso estate have unearthed some new work they found in his flat in Mougins and are offering it up for sale. Talk about cash in the attic… When it comes to dear old Pablo, if you snooze, you lose – we've learnt that the hard way in the past. Claudia and I are up early so we don't miss out. I'm trying to get a glimpse of who else is trying to get their paws on these; ah, no surprises that it's mostly influencers with the money these days. I'd better turn away or they'll all want to reel me in… Let the bidding begin!

I've never been to a sale like it – it's a feeding frenzy, a carnival of capitalism, the great migration of sense seems to have taken a detour via the land of nod. I've never seen so many paddles in the air. Don't get me wrong, I hold Pablo in the highest esteem, but some of these prices make you want to faint. We're well over the asking price, but if you think I'm losing out to this spray-tanned lot you can think again…

"Going, going, gone. SOLD! To the ravishing cat on the front row."

GOING… GOING… GONE!

23 FEBRUARY

Headshots are back from the studio.

One word: *Reow.*

It's half term and Claudia has taken her youngest to see *The Aristocats* in the West End. Why she feels the need to go all that way when they have the real deal prowling about their heels at home is anyone's guess.

Smartie is at the vet so it's just me and Rollo in the house – you can imagine the conversation; it's about as intellectually stimulating as watching paint dry. He's been chasing his tail for two hours straight now, or is he trying to sniff his own arse? Honestly, he's been on this planet for seven years but you'd be forgiven for thinking he was born yesterday. No no, Rollo, that's not a friend, that's a mirror... Right, I'm heading for the wine cellar. Ciao.

7 MARCH

Still no auditions coming through from my agent. This is what happens when you get headshots done by the intern. Whether to ask for a refund or not...

Paris – *J'adore mon amour*. The city of love, the city of poets, and my sixth home. Claudia and I waltzed here aboard the Eurostar, which was *très sympa*.

J'arrive à Paris. Au revoir, London.

We're staying in the 1st (where else?) in hotel Cheval Blanc (of course), and we have the entire top floor to ourselves; our cosy rococo retreat. After a kip and a coffee, the designer from Chanel joins us in the premier suite, an army of assistants in tow. It's quite the entrance. I keep telling Claudia that assistants are like cocktails, one can never have too many.

It's always nervy before a fitting. 'Will the shoe fit?' and all that. Claudia is as chilled as they come. The team from Chanel are a wonder; so chic as they go about their business. It's poetry in motion. I've no part to play here, so I slink off to find the afternoon tea and gorge myself on *macarons* and *gâteau*. Oh, don't look at me like that – it's what Marie Antoinette would have wanted.

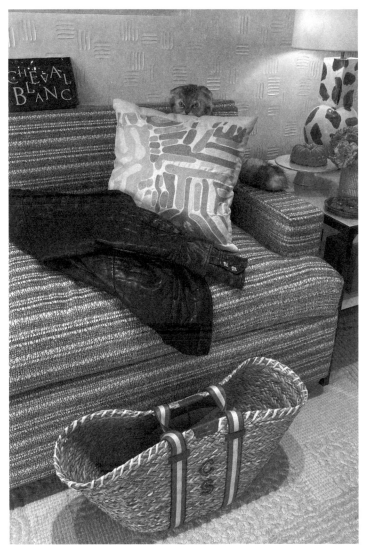

Coucou!

The runway calls and Chip must answer. Balmain are closing the day with the 8 pm show. We glide through the traffic to a spectacular catwalk under La Tour Eiffel and are shown our seats. I don't need to tell you that we're front and centre. Well, Claudia is on the front row, and she's my human cushion. We've got Linda and Christy to our left and the steely editor of US Vogue to our right, who thaws to my purrs and extends a palm for me to grace.

All the top cats are here. The lights are lowered. I lick my lips. Wow, Balmain is breathtaking. It's fast and furious – a fever dream. The applause thickens into thunder as Olivier appears. He blows a kiss to me, which I return with a coquettish wink. His smile says what everyone is thinking; there's only one cat here who can walk this walk.

10 MARCH

Sunday, and Paris is ours for the day. Part of the charm of this city is that you can get lost in it. No one is hassling me for photos or wanting to stop and stroke me. You wouldn't want it every day, but for a weekend it is perfect. Claudia and I prowl around the vintage markets, take a stroll along the Seine. We stick our paws in the Pompidou and sip coffee in the cafes. For dinner we meander through Place de la Madeleine to Caviar Kaspia. You can't get a booking here for love nor money, but for us there is always a table by the window. Jazz coils through the open door as Naomi joins us. *Une autre chaise, s'il vous plaît.* The triptych is now complete. Gossip and laughter swoon into the midnight air… *Ah Paris, mon amour.*

Avery moving day. We are visiting Battersea Dogs and Cats Home, a charity which gives shelter to the down and outs of the four-legged world and finds them new forever homes – hint hint, dear reader.

Make no mistake, philanthropy is my middle name. Once a year I take a trip to the kennels and prowl around the place. It's no fur off my back. But oh, you should see this place; Tabbies, Persians, Siamese, Shorthairs, every breed under the sun is in here. My heart bleeds for them. These poor things, I've never seen faces so hungry for love.

We did a few laps of the place, shook a few paws, listened to stories of how they came to be here. All deeply affecting.

Silence all the way back home. Hard not to be moved by the day. Simple dinner of tuna carpaccio and early to bed.

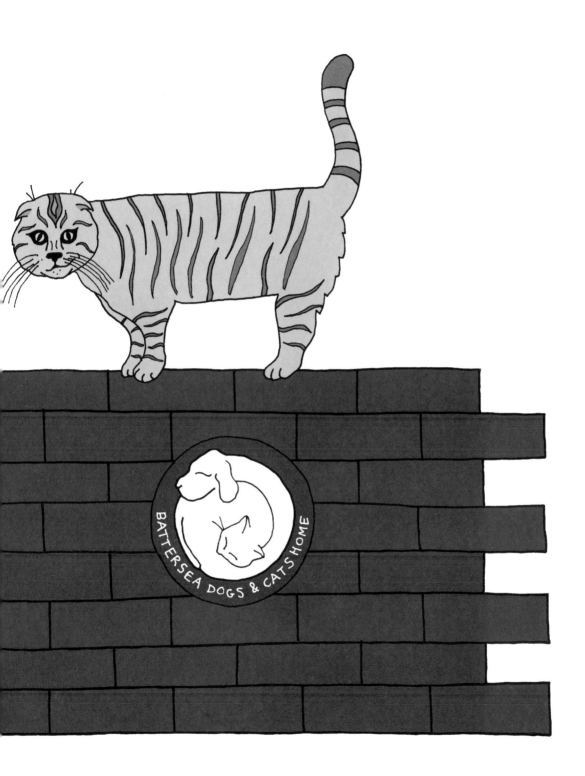

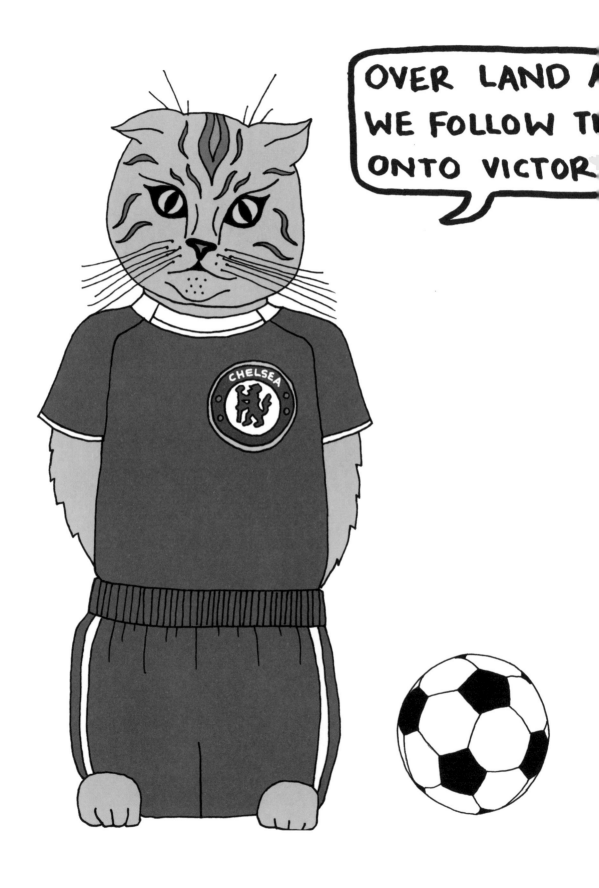

10 APRIL

Can barely speak, voice is gone but oh, what a night. Stamford Bridge, under the lights. Chelsea vs Bayern Munich. Three-course dinner before being shown to our box.

The match will go down as a classic – Chelsea go through on penalties. Kanté blasts it in and pandemonium ensues. As always, we're invited to the changing room after the game. I have to avert my eyes at the low-hanging fruit on display and steer clear of the locker room antics, but the team aren't letting me off that easy: I'm ceremoniously handed from player to player, kissed and cuddled and held aloft like some furry World Cup.

Commiserations to Claudia…

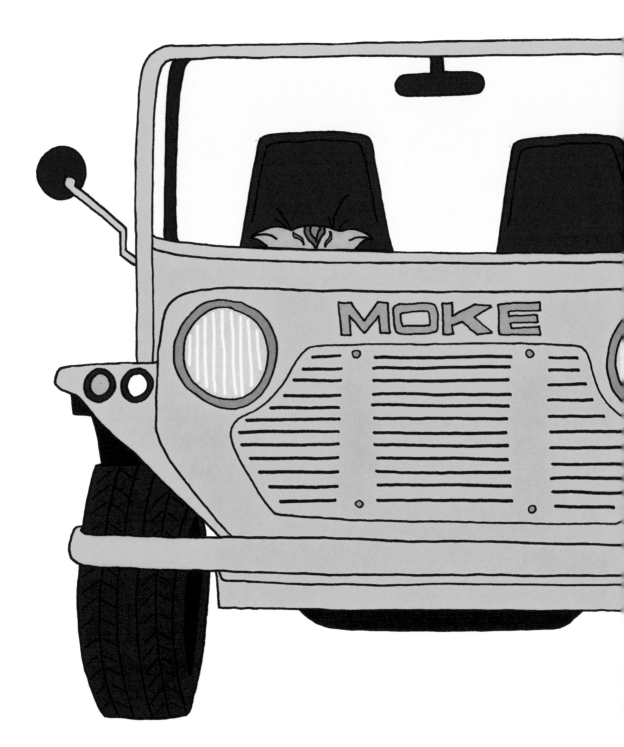

Spring has sprung, and all the family are home. I can't complain, it's cuddles on tap. Big family lunch with all the trimmings, after which we pile into the Moke and take a spin around the grounds. I'm like Toad of Toad Hall, a boy-racer all over again. Toot Toot!

The family are all feeling rather carsick now. Maybe it's about time I finally get some driving lessons…

4 MAY, ITHACA, GREECE

A much-deserved break. We're setting sail for the high seas; we have chartered a yacht – two weeks around the Greek islands. Bliss. This really is the life; the sun on our backs, the wind in our sails, and more fish than you can shake a stick at. The only snag is having to wear this hideous life jacket which Claudia is insistent I keep on at all times. Now I know I can't doggy paddle, but this thing really is a crime against taste. Although, this whistle is rather fun to play with! The kids are out on the jet skis, Claudia is immersed in a thriller by this new author everyone is raving about called Elly Conway, and the afternoon is mine – I think it's time to start my memoirs…

Hold that thought, must dash – swordfish tartare is being served. Captain's orders.

must be brief, something just happened which has me rather thrown. While Claudia was snorkeling with the kids, I was carefully two-stepping along the starboard side when I get a call from my agent... Word on the street is that there are more than concrete plans for a live-action remake of *Garfield*. I nearly went into cardiac arrest. There it is, my big break, right there on a plate. Let's be real now, who else could play that part?

My agent emailed through all the details, the shoot is going to be a long one, seven months on set. I'm totally torn. Seven months away... Of course I want the part, it will do wonders for my career, but I also need to think of Claudia in this. I couldn't leave her for seven months, not with Smartie and Rollo for company.

12 MAY, HYDRA, GREECE

o sleep last night. Although the sea was calm, my head was anything but. I'm a raging tempest of indecision. It's impossible to enjoy myself with this hanging over me. Oh, make the sirens stop. Someone just tell me what to do…

14 MAY

Fortune's wheel has turned; the part of Garfield will be CGI…

16 MAY

t's no walk in the park being an actor these days. While I am all for technology, well, mainly Teslas and Uber Eats, this CGI is robbing us thesps of a career. There's no substitute for talent, though – that's what we must remember. Early evening yoga session with Claudia followed by a gong bath, feeling much more zen.

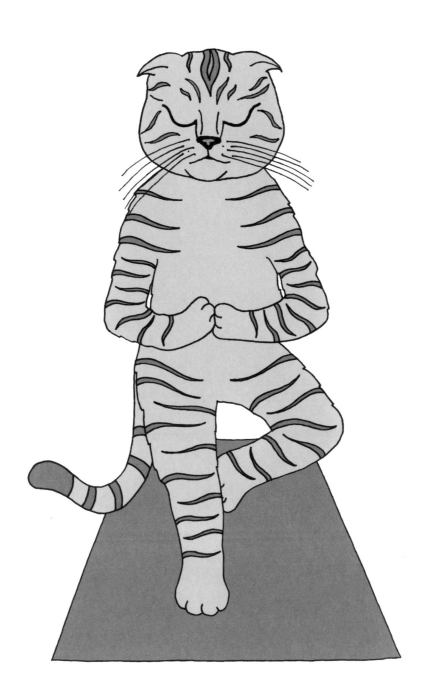

24 MAY, LONDON

Chelsea Flower show, a treat for *all* the senses. Claudia and I arrive through the Royal Arch; I am left alone with the corgis by the Japanese water lilies. They are very dignified and poised, for dogs. We share tips for groomers, and I find out there is a hidden room full of treats at Fortnums! Of course, I pretend I knew that already. Oh and look, Larry the Downing Street cat is here too. We haven't seen each other since the Royal Wedding.

Larry's full of beans and gossip as always. We slink off behind the geraniums and he fills me in on all the goings-on in No. 10, which certainly makes me cock a brow. We pose for the press together and then, like that, he's gone off to have a meet-and-greet with the Ugandan ambassador. I tell him to get his people to call my people and fix a date at his place – I'm longing to see the new wallpaper…

1 JULY, WIMBLEDON

Ascot, Henley Regatta and now Wimbledon – nowhere beats England in July (even when it rains). Claudia and I have tickets to semi-final day. A treat both on and off the court. Rybakina vs Jabeur followed by Federer vs Nadal. Not a bad set list. But the real showdown is in the royal box where we're sat, with the uber-cool modelling sisters and their BFF: Gigi, Bella and Kendall. Naturally, the cameras are far more interested in us than they are with the tennis. Lots of snuggles and gossip in between sets and before you can say 15-love, they have asked me to be in their next campaign. This cat has got the cream (sans strawberries).

7 1 7 7 Elen

6 6 6 Ons

2 ♛

BAKINA	2	10
ABEUR	1	8

I'm not sure my liver loves 'the season' as much as I do. Someone pass me some aspirin, sharpish!
I shall give up drinking, try CBD gummies. Do they come in chicken flavour? Note to ask housekeeper.

Finally, a part that gets the pulse racing. This could be my big break. A remake of *Puss in Boots*! I woke up to seven missed calls from my agent. Producers want a self-tape to show the execs in LA by 9 pm tomorrow. How that's going to be possible with my visit to the groomers today is a problem for someone else to solve…

There's no script but the invitation is to make it my own. But how to play it? Too much and they'll think me OTT, too little and they'll mistake me for a modest mouse. It's a fine old balance, this acting malarky…

Little to no sleep. Did the self-tape with Smartie behind the camera. One must make do with what they have… Agent seemed pleased.

25 JULY

Hard to find the words. Bereft barely cuts it. The part of Puss
has gone to the superstar of the moment, that Euphoric beauty…
Imagine her in UGG boots. I want to scratch out my eyes.
Of course she'll pull it off, though – there's nothing she can't do.

Magnanimously,

CLAWRIDGE'S

6 AUGUST

The black dog has been to stay and shows no sign of leaving... I haven't washed in weeks. Strongly thinking about packing it all in, maybe this cat just isn't made to be a star...

The concierge are being more than supportive, they know I am hiding from the world. I'm being spoiled rotten; fresh sheets every day and enough room service to feed an army, but truth be told my appetite has deserted me, along with my confidence.

My crystals are my only support right now. #Pray4Chip

10 AUGUST

Have been burning sage all week but still not feeling cleansed of my own dark thoughts. I speak to no one... except the person who brings me room service.

13 AUGUST

At last, something worth getting out of bed for. Fresh from the courier, a darling card from my favourite casting director asking me to walk for Versace. If only they could see me now! Oh, and look – Claudia can come too. Of course, we wouldn't miss this for the world. But first, London... it's time to put my game face back on.

London Fashion Week. The work never stops. There's nothing like being on home soil, though – the concierges know you by name, the drivers know your address, and it's more than OK to drink before midday. A champagne breakfast at Claridge's. We are impeccably dressed (as always) and on sparkling form. Breakfast arrives with just the right amount of flourish – the service here is 'the real Tabasco'. Speaking of which, can I get some for these oysters?

16 SEPTEMBER

Wow, the mind is well and truly blown. Just when you think you've seen it all… Richard Quinn, take a bow and then another. The show is the talk of the town; big florals and big hats with a deliciously dark edge – just perfect. I've never seen a standing ovation last so long, everyone was rather jealous of my four legs by the end of it.

The fun doesn't stop there – we are off to Annabel's for the British Vogue party, which is not a bad place to rub ankles with the great and the good. If I can't sniff out a part in a film or two here, I might as well hang up my collar. Only snag is that I've been shafted onto the kids' table, where all they do is vape and stare at TikTok. Safe to say there's no career defining role for me here…

Ah, that's better. Claudia has rescued me and popped me on her lap next to that trailblazing visionary, Edward. Much more my scene. The man is class personified. His dog has been left at home, so I have his undivided attention. We're getting on more than well; lots of eye contact and scratches behind the ears. He's talking with real fervour now, says he has an idea for us, something top secret but he wants to talk more, away from prying ears. This could be it, my big break!

Back from Fashion Week and the Delevingne sisters are joining us for a debrief dinner... It's full of gossip from the runway; who's taking off, who's set to land, and who arrived (fashionably) late. The conversation is sparkling, but I'm struggling to keep up – Fashion Week, it takes it out of you. I make my excuses and slink off for some shut eye...

God it's good to be back on the continent. It's not the heat that hits you when you land, it's the style. I don't know what they put in their DNA over here, but I want some of it. Everyone and everything is gorgeous, even the dustbins can strike a pose. Versace has a limo waiting for us. We shake off the paps and cruise beneath the snow-capped mountains, entering the city by Via Monte Napoleone. I can taste the runway. The calm before the storm. The Versace team are there to greet us. How I've missed the scent of Donatella's embrace. But we're not alone – the Supers are all here too. They'll be closing the show together, the internet is about to be broken. It's like the '90s all over again and I love it. The girls have a green room each (I've kindly let Claudia share mine), and they're running in and out of each other's like schoolgirls. Giggles tumbling up and down the walls. It's good to have the gang back together.

Espresso and sfogliatelle for breakfast. Don't tell Claudia but there's something about Milan which has me dreaming of a cigarette. You know what they say, when in ... Milan?

There's a dress rehearsal to make sure everyone knows their place; the Supers will each be stood on different plinths as the curtain comes up. Some questions over who should stand where, but it's perfectly obvious to me that I should be atop the tallest one, it would look plain odd otherwise.

For logistical reasons it is deemed best by all that I remain on the FROW, just as the show begins. I will pick this up afterwards with management. For now though, I am too excited to care. The lights dim – showtime!

Prints and patterns swirl before me, pop art and politics collide on legs, and then it happens – the grand finale. The curtain is raised and there they are, the icons of their age. The cameras go wild. I howl with joy.

T elephoned my agent to ask whether any auditions were on the horizon. There is a pause and flustered apologies about the signal. This isn't the first time. I play with my sushi and let the excuses wash over me… I think it's time to renegotiate their cut.

Feeling rather miffed if truth be told. I've just heard on the grapevine that they are turning *Cats* into a movie. What's worse is that the auditions have been and gone. I never even got a look in – and I AM AN ACTUAL CAT.

Where is Claudia? I need a cuddle, then I'll calm down.

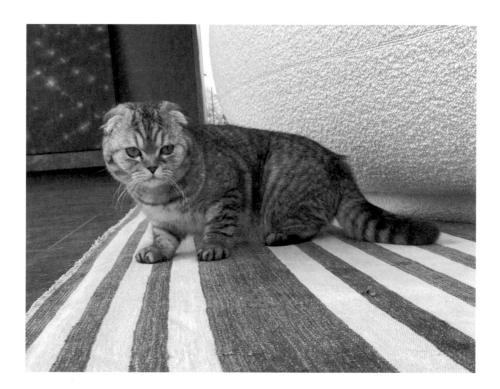

While I am a sucker for the sun, my favourite season has to be autumn – the leaves begin to burn, pumpkin lattes are back on sale, and cuffing season is in full flow. Is there a more perfect time to be alive? As for me, it's time to push the shades and sun hats to the back of the wardrobe (at least until I get my winter sun) and start donning my more earthy tones; browns, yellows and a dash of ochre here and there. I suppose it's time I should start growing my winter coat but oh – the dreaded mid-length month – nothing a trip to the hairdressers can't sort though.

Tuned in to Hollywood Today while taking a gentle stroll on the treadmill and nearly fell off. The lead in *Cats* has gone to that singing and dancing taxi driver!

Cancelled my PT and sulked for the rest of the afternoon. Was foul to Claudia and chased a mouse into a Magimix…

T rue to their word, Vogue have arranged to have dinner with me and Claudia at Nobu. Out of mutual respect, we pull out all the stops for each other. Claudia is in a devastating bodycon by Alaïa – it's all cleavage and curves. I'm donning a bow tie, which is just the right side of Killing Kittens. Meow.

We meet at the bar for passion fruit martinis and nibbles. Edward gets right to it: he wants March's British Vogue to be a love letter to cats all over the world; how felines shaped fashion.

Reader, he had my curiosity, but now he has my attention. As you can imagine, every photographer in town wants to snap this one.

A couple of briefs for the inside story; the jungle, the big five, but I push for something more classical; Egypt, the Pyramids, the dawn of civilisation. Vogue seem taken with this. Busily, we talk into the night...

We're off to the Frieze Art Fair VIP preview. It's always a pleasant affair but I'm only there for the company, not the art. The Goldsmiths lot are all in attendance, and we spent much of the evening discussing the future of NFT's. I'm all in. It sounds much more preferable to being drowned in formaldehyde. Got into awful trouble with a security guard for relieving myself on a bronze installation. I pleaded ignorance, I thought it was a lamppost. Afterparty at the Groucho with the YBAs et al. The nineties do sound like fun!

FONTANA AND I HAVE VERY SIMILAR STYLE

FaceTime with Vogue who have confirmed the creative; we're going with the Egyptian concept. Claudia to be Cleopatra, Chip to be the Sphinx. An ancient communion of the feminine and the feline. This will be iconic, I'll be on every bus and newsagent across the world. Every casting director in town will have eyes on me. And to think, I was actually flirting with the idea of joining the local panto!

The team for Vogue have just pulled up. I do love a fitting, it's when I really get to exercise the meaning of indecision – could we maybe just try one more dress? Ha! Styling is on point as always, every option is ravishing. It's fair to say I'm going to be the 8th Wonder of the World.

We're trying on the outfits in the drawing room, Claudia is donning an emerald-green custom gown and headpiece by McQueen – she looks like the fountain of milk and honey – when suddenly there's a shriek to make the testes shrink. Rollo has bounded in all covered in mud, planting his paws all over the McQueen. I don't know where to look, the shame of association is too much to bear... Who will rid me of this turbulent hound?

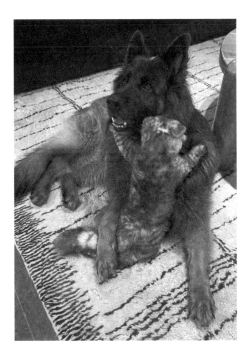

Urgh, woke late to a head like thunder. I should hardly be surprised, it's par for the course when one of the UK's favourite chat show hosts invites you around for 'Hawoween'. His freak boutique is an annual fixture and not one you want to miss. I usually run a mile from fancy-dress, but for this I make special allowances and raid the children's dressing up box. Claudia and I went as Dorothy and Eureka from the Wizard of Oz. Yep, we nailed it.

I unfortunately had to endure a tedious hour in the company of Rollo. Honestly, that hound is nothing more than a savage – eating up canapés like they were going out of fashion and cocking a leg every 10 minutes.

ALL HALLOWS YVES

I managed to sneak away and re-join the party. Mind you, I'm paying for it today. I should have called it a night when Claudia bid her farewells. The price you pay for late night fun.

THE NILE RITZ-KITTEN

CAIRO

6 DECEMBER

Flew to Cairo, I took a sleeping pill with my
sardines and woke up as we touched down.
Bliss. Checked into the hotel, which has improved
a lot since the new manager came on board.
Dinner with the photographer and his entourage,
who talked me and Claudia through the vision
for the shoot tomorrow. We're in very good hands.

Early rise for hair and makeup. Not that I need
much work anyway. With our game faces on, we're
helicoptered to the top of the pyramids. Claudia
and I are clad head to toe in Dolce & Gabbana.
It's Cleopatra with a hint of kink. The whole
shoot was a joy, and the early rushes looking
very promising indeed. Iconic is the word on the
street... This will do wonders for my profile.

Snow is falling and silly season is upon us. Off to a very flamboyant evening of carols by candlelight, what could be more festive! I'm sporting my Christmas jumper, but I draw the line at the red nose the kids wanted me to wear – I'm a cat, not a novelty reindeer. Everyone is full of mulled wine and song – it makes the heart sing. All the family friends are here, blasting out the final chorus of 'O Come All Ye Faithful'. Elton was on the piano, of course, leading us seamlessly from the carols into the classics. I was pride of place atop the Steinway, conducting the merry crowd like Santa's little helper…

Oh God, who let Rollo off his leash? The mince pies!

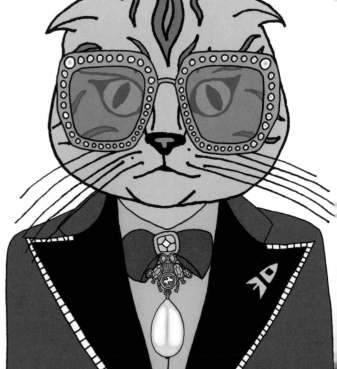

"Simply having a wonderful Christmas time…"

When I hear people say they prefer giving presents to receiving them, I'm immediately suspicious. Christmas shopping, is there anything more dire? The stores are heaving, the traffic is glacial, and you end up splashing the cash on people you really don't have time for. I mean, what on earth am I meant to get Smartie – a guide to living with an inferiority complex? Actually, that would be a rather good present… As for Rollo, he'll be lucky if he even gets a sack of coal.

Urgh, St James is at a standstill, I ask the driver to take me to Liberty – it's a smash-and-grab job and then a much-needed cocktail!

ur first night as a family back together. It's really rather magical, the fire is lit, the tunes are on, and everyone has a drink in hand. I'm curled up by the fire, penning my list to Father Christmas,

Dear Santa,

As I've been so devastatingly good this year, I don't think it's beyond me to ask for the below:

• Louis Vuitton cat carrier
• Hermès perfume and conditioner
• Diptyque Le Poisson candle
• Fortnum & Mason sardines
• Chanel collar
• Harrods anchovies
• Custom 'Chip' Barbie doll
• More sardines

Hope Rudolph can carry it all...

Love,

Chip x

To say Smartie has 'enjoyed' herself over New Year's Eve would be an understatement. She spent the night shitting everywhere, having completely overindulged, as always. And, to top it off, she's hacked up on my favourite Hermès blanket.

It's time to get my claws out…

The kids are back at school, and Claudia has decided it's time for a bit of 'us' time! I know what that is code for – we're hitting the slopes. We fly to Garmisch-Partenkirchen, which really is a chocolate box of a town, both from the air and on the ground. The hotel has matching faux furs and steaming glasses of *Glühwein* waiting for us on arrival.

Claudia and I are in a suite complete with indoor and outdoor spa, and there's enough fresh snow in this resort to keep the fashion crew busy.

While Claudia is very much here for the skiing – she's all first lifts and fresh tracks – I prefer a slower start, a steam and sauna, then a thorough and dedicated interrogation of the continental breakfast. I might venture into town for a saucer of Alpine milk, but I'm not going anywhere near a cable car. As for those monstrous ski boots with buckles and bindings… you can think again.

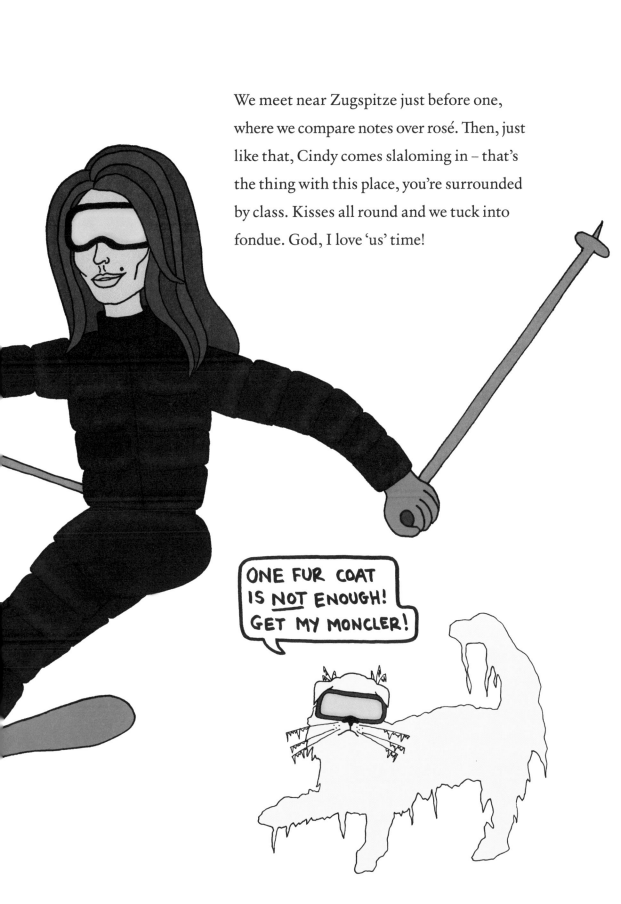

We meet near Zugspitze just before one, where we compare notes over rosé. Then, just like that, Cindy comes slaloming in – that's the thing with this place, you're surrounded by class. Kisses all round and we tuck into fondue. God, I love 'us' time!

Well, hello… I know one mustn't believe everything they hear on the grapevine, but some gossip is like Reblochon – impossible to resist. Whispers are gathering in the Hollywood Hills that plans are afoot for a live action remake of *The Lion King*. All the big cats are being considered. And yes, that includes me, my agent has just confirmed it. I'm having a screen test tomorrow, time to purrfect my roar…

24 JANUARY

Up early to warm up my vocal cords –

AHHHHHH ZABENYAAAAAAA!

My stage is set – it's a Zoom audition in the study. The producers feed me the lines, and I gobble them up before treating them to an a cappella rendition of 'Hakuna Matata'. I take their silence to mean they're impressed. I offer to do it again, this time imagining I *am* the antelope. They proffer their thanks and say they'll be in touch. It was all over so quickly. Now, the agonising wait begins…

27 JANUARY

Can't sleep. Can't eat. Very hard to think about anything else, this could be life changing.

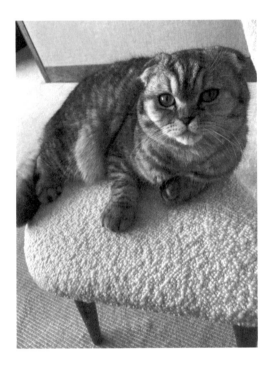

29 JANUARY

Positive sounds coming from my agent. I'm still in the mix but there's a catch – they want me to grow a mane. I see their point, but isn't that binary gendering all a bit yesteryear? I really don't identify in that way, it's not who this cat *is*...

30 JANUARY

ittle to no sleep. Long discussions with my team. While the part would be brilliant for my career, my identity is more important. My agent thinks I'm insane, but Claudia understands, she always does. With a heavy heart, it's a regrettable pass… Oh, the circle of life…

4 FEBRUARY

t last, something to put a smile on the face. The early copies of British Vogue's March issue are in and it is… well, utterly breathtaking. Obviously, they went with the solo cover. Powerful and subversive, classical and contemporary, coy and coquettish – everything it needed to be. I forgot how good I look in gold… Vogue have tripled their print run. God bless the glossies. All eyes on me now…

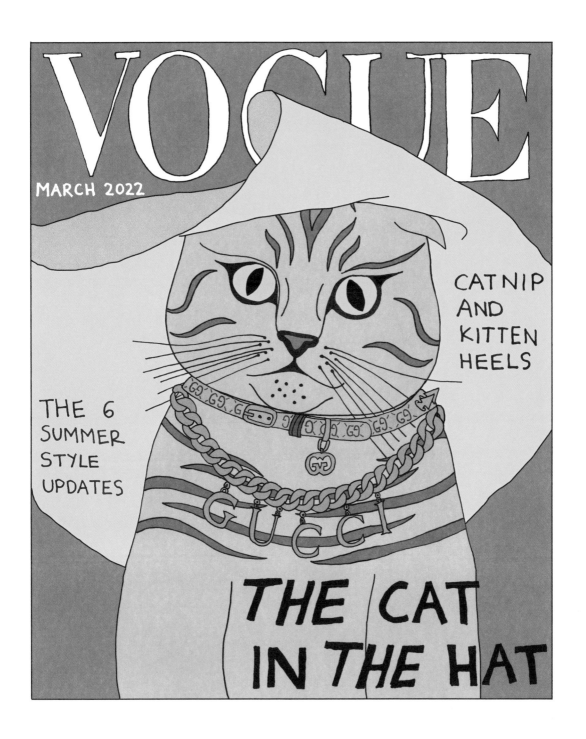

We're back in the Big Apple, and I'm hungry for a bite of it. Yes, the countryside is quaint and all, but sometimes you need a bit of soot and sin under your skin – it's good for the soul. Mischief almost certainly awaits. Claudia is here for Fashion Week – Proenza Schouler have asked her to open the show, which is of course an honour, but somewhat short-sighted; the show can only go downhill once Claudia has done her part, in my humble opinion… The fitting is seamless, every outfit fits her like a glove, curves in all the right places. It's all so effortless on the eye.

They have kindly fashioned me a couple of bangles for my paws, studded little things which sing with every step. I might just 'forget' to return these…

6 FEBRUARY

Woke to the sound of the concierge almost breaking down the door. Could have sworn I put up the 'do not disturb' sign before I got back in… My head's a bit furry if truth be told, I'm never mixing tequila and cat milk again.

Jesus, Claudia's show! No time to tell all now, I'm heinously late. Who do you have to scratch in this city to get a chauffeur?

Tail firmly between legs. I hacked up all over the FROW. Escorted off the premises and missed the entire show. Claudia won't look me in the eye. She's not angry, she's just disappointed… Oh, the shame! Back home I'm sent straight to bed without my Daylesford milk. Smartie thinks it's Christmas Day.

Today is spent commemorating an old friend. A titan of the industry, a peerless pioneer. His hair, those glasses, those *collars*… What more could a cat want? It feels like only yesterday that he and Choupette were here, sitting with Claudia and me, laughing, joking, plotting our next shoot…

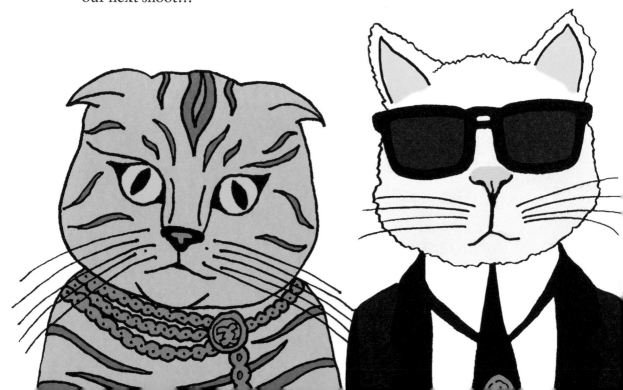

A day to savour: one must never laugh at the misfortune of others – one false move and the boot could so easily end up on the other paw – but the reviews are just in for that Feline film and well, I'm glad my name is nowhere near it. I spat out my morning milk with glee!

The family are away, so the house was mine for the day. I lit some candles and spent many happy hours scrolling the comments section of Rotten Tomatoes. Bliss. And to think how snubbed I felt all those months back… A bullet well and truly dodged. Speaking of, when is the next *Matrix* movie being cast?

t's all go here. The house is a circus. I've not finished my first saucer of milk and already I've seen enough steel-capped boots and high-vis jackets to make me want to hack up all over the cashmere. Handymen, caterers, florists and security guards have taken siege of the place – it's like the storming of the Bastille, only more coordinated, and with blinis...

What's all this for? Oh, pardon moi – it's this old Tom Cat's birthday and the family are throwing me a surprise bash. They think I haven't a clue. But please, as soon as I saw the sardine piñatas, I smelt a rather large rat... The 'do' itself is nothing flashy, a few hundred of our nearest and dearest.

I did a little re-jig of the seating plan once everyone had retired to bed last night. It wasn't working to my professional advantage. The great and the good of Hollywood are here tonight, and I haven't had an audition in months. It's time for some serious networking. Anyway, must dash, I'm being rather rude – Tom Ford has just sent the latest collection, which my stylist will no doubt want me to sport tonight. Decisions, decisions... More anon!

8 MARCH

What a night, we really know how to throw a party. Hard not to get seduced by the fun of it all, but business never sleeps, nor do any of our friends, it turns out.

Today I'm very excited! The gossip headlines are this: a big film is coming, it stars a cat, I could be a shoo-in… Watch this space…

And it turns out I was right! I woke to a volley of missed calls from my agent. Funny how agents work, isn't it? If ever you want to get hold of them, you know – for a chat, or a cuddle, or advice on what shampoo-conditioner to use, they're far too busy to talk. But as soon as someone wants to talk dollars, then they're all over me like fleas…

I'll let them off this time as this one is a biggie – Apple/MARV have announced *Argylle*, a brand-new spy thriller. There's a top dog director attached, my agent tells me. Industry chatter is deafening, people desperate to know more.

And the best thing of all, I'm going to be the star! Yes, you heard
that right. I know, I know, even I had to get my agent to repeat
it seven times over. It turns out the talents of this globetrotting
glamour puss haven't gone unnoticed. I'm a shoo-in for the part.
All those auditions, all those rejections, finally my time has arrived.
And about time too…

18 MARCH

Casting for *Argylle* is underway and the rumour mill has gone into overdrive. There hasn't been this much speculation since I got papped coming out of… well I can't tell you whose room it was. The internet is positively breaking. Actors, we're a competitive bunch and ruthless when we have to be. No one wants to be left out in the cold, you see. Which reminds me, our housekeeper needs to get that cat flap fixed…

Had a terse tête-à-tête with my agent: turns out the producers want to open up my part for auditions. Inside I'm fuming, but I don't let this rile me. I know it for what it is; a front, a pose, a gesture of indecision to get a better deal. No, that part isn't leaving these four walls, mark my words.

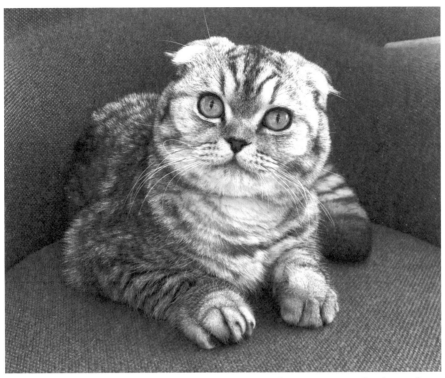

Someone answer the phone, please.

28 MARCH

This is dragging on far too long now. Calls coming in from lawyers saying they need a trained cat to be on set. I mean, really? Which other cat out there can tell the difference between a claret and a Chianti, their Brahms from their Beethoven, and can lip-sync every word of *Hamilton* on double speed? A trained cat... Honestly, I know more social faux purrs than dogs do tricks. No training needed here, just pass me the goddamn contract.

3 APRIL

Still no news. The family are at the Oscars, so I've anchored myself in the study and taken to doomscrolling the internet. The web is awash with cats I convince myself are also going for my part. None of them are anything to fear though – I could eat them all for breakfast (verbally speaking). But then I got the fright of my life: Smartie sidles past me and hisses something about getting an audition for this very film! I nearly vomited on the chaise longue. Checked the calendar to make sure it wasn't still April Fools. They can't be serious? This is a prank, I've been punked, Ha!

Seriously though…

5 APRIL

It's fair to say my sense of humour has evaporated, along with my zest for life; I need this part, and I need it now. My agent organises a car to take me to their offices, they say they need a 'little chat'. Apparently the director needs a self-tape. I laugh and help myself to a Statesman on the rocks. This cat doesn't screen test.

6 APRIL

I spend the afternoon getting a multi-vitamin drip. Earlier my therapist dared to suggest that I might be a little jealous of Smartie, that tiresome fluffball! I assured him I was just low on B12, and promptly fired him. Such toxicity, I don't need it.

9 APRIL

Production lawyers and my reps are at war. They forget that people talk in this town, and I know what I should be getting for this film. The number they're putting to me… well, frankly I'm insulted. I may be a cat, but I'm the *lead* cat and that's worth its weight in saffron. I'm remaining calm about it all; it'll all be sorted by tomorrow. This is a game of cat and mouse, and we all know how that ends…

11 APRIL

Finally, civilisation has seen sense; the part is mine. Were we ever really in doubt? Deadline will announce it on their channels tomorrow, and of course it will be trending for days to come… Move over DiCaprio, there's a new cat in town.

13 APRIL

Smartie hasn't been around to congratulate me on the news. I thought she was dodging me, but I hear she hasn't left her bed for days. Sad really… Has no one told her that jealousy isn't a good look?

DEADLINE
HOLLYWOOD BREAKING MEOWS

KEEP IT IN THE FAMILY: CHIP THE CAT TO STAR IN MATTHEW VAUGHN'S 'ARGYLLE'

Shooting schedule has landed on my bed. A four-month shoot on locations which I wouldn't turn my tail up at; Château Lafite Rothschild is crying out for a long weekend away. Couple of points to be ironed out with the contract. Firstly, I insist there won't be any animal handlers on set. I'm not letting any Tom, Dick or Harry grab this pussy. Secondly, there is no mention of a driver in the contract, so that will need sorting, pronto. Otherwise, all looks good. Now, where do I sign?

I PUT THE 'CHAT' IN CHATEAU LAFITE.

16 APRIL

Don't distract me! I'm deep in research. I've spent the week studying the script, and I'm playing the part of Alfie: a suave and dangerous cat with the best lines in the film, of course.

I am only allowed to share crumbs with you, but what I can say is that I am, essentially, the hero. And yes, I'll be dialling up the sass!

I've begun my homework, re-watching the famous 'Alfies' of films gone by – first Michael Caine and then Jude Law. I'm the first to admit those films haven't aged well, but that snooker table scene is quite something… But I need to get to the core of Alfie – what does he think, how does he MEOW, has he had the snip? I think the best way to approach this is to go method, immerse myself in the part – it worked for Daniel Day-Lewis, and it will work for me.

With the contract all sorted, we are off to Monaco for the weekend. It's the Grand Prix. I've no interest in the sport itself, but I'm partial to what comes with it: the Princess Grace Suite, the view across the harbour, the catwalk down the paddock. We have an all-access pass to the pits, and the world number one kindly popped me on his lap and took me for a spin around the city. We saw all the sights in 90 seconds flat!

The race itself was nothing more than noise, but it was fun to wave the chequered flag. I joined the boys on the podium for a spot of champagne, and then Williams Racing invited us to drinks on their balcony that evening. Jaws dropped when Claudia and I made our entrance. Our matching Dior outfits were the talk of the town, and the compliments and champagne didn't stop all night. Lots of congratulations coming my way re: *Argylle*, which I batted away with a blush and smile. So this is what stardom feels like…

Back home and already my doorstep is full of gifts and fan mail. It seems that every brand in town wants to ply me with their latest goods. I'm not complaining (Smartie is), I'm just at a loss as to where we're going to keep it all. We're gonna need a bigger boat…

But what's this waiting for me? Only the hottest ticket in town, the Met Gala. Of course I've been invited, it comes with the territory now that I'm a movie star. In fact, Valentino have asked if I will be their guest of honour. I accept on one condition: that Claudia can be my plus one. The theme is a winner – *Heavenly Bodies: Fashion and the Catholic Imagination*. I'm purring at the thought of it. Forgive me Father for I have already sinned….

Claudia and I spend a very happy day plotting what to wear on the sofa. We're full of giggles, swiping through the albums of Galas gone by. It's all about making a splash. It's calling out for a double act – saints and sinners, angels and demons, Saul and Paul. Wait, I might just have it: vicars and tarts! That'll put the cat amongst the pigeons…

Now this is the life. *Argylle* pre-production hair and makeup – aka, HEAVEN. Car arrived at 10 am to whisk me off to pamper-city. Hard to suppress a smile as Smartie chased us down the drive. Bless her, but there's only room for one cat in Hollywood, I'm afraid… Arrived on set and was immediately at home; beauties in towels and smiles serenade you at every turn, a glass of champagne Mx Chip? Would you like the manicure or pedicure first Mx Chip? Scented towel Mx Chip? Finally, someone who speaks my language. Five hours later I'm shitting roses. A star is well and truly born.

I'M FELINE GOOD

A quiet walk in the countryside with Claudia. It's important to make the most of these moments, they'll be few and far between going forwards… But perhaps they are already a thing of the past; as soon as the footpath fed into the village, the paps were upon us. Snapping away like seagulls to a vinegar-soaked chip. I'm used to it now, but I wish they would respect Claudia's privacy more. My fame is not her cross to bear…

Sketches for the Met Gala outfits are just in. The vicars and tarts creative is a polite no. Valentino has gone for something more celestial – a halo for Claudia and wings for me. Reow! Someone put this cat on a leash… No, don't actually. That's for Rollo.

26 APRIL

A most peculiar day. I'm minding my own business, quietly learning lines in the sauna, when Rollo and Smartie corner me. They say that they've had enough, that I'm getting too big for my paws, that all this movie malarky has gone to my head. They're obviously grieving over my success – first it was shock, then it was denial and now it's anger. It's totally natural, soon they will learn to accept it and come to appreciate me for who I am – a star.

27 APRIL

First day due on set of *Argylle* and the car arrives at 6 am. 6 am! Endless attempts from Claudia and co. to shoo me out the door. I stay put up on the chandelier. My agent has made it very clear: I'm not moving anywhere before nine. Calls coming in from all directions. Eventually it's agreed, they'll rework the schedule. It's really not that much to ask…

Today is much more like it. At *nine* a.m. I waltz on to the drive where a runner, which I assume is an ironic title, scoops me up and places me in the back of the Mercedes. The seats are heated, there's a TV in the headrest and a copy of my script is freshly ironed, along with the FT. What is it exactly that people find so arduous about commuting? I would be lying to you, dear reader, if I didn't have a tingle of nerves in my tummy, but my face did not betray me as we pulled up on set. I slink down from the car, all heads turned Chipwards. A thousand smiles. I am introduced to everyone on set before being whiskered away to my trailer. It's all go!

It may look a lark from where you're sat, but making movies is a serious business. Everyone is in character on set, full method acting. Forgive me, I can only use our character names from now on; I'm dying to spill the beans but secrecy is everything in showbiz. I've signed so many NDAs you'd think I work for MI5. Anyway, all will be revealed soon.

Must dash, *Alfie* is being called to set...

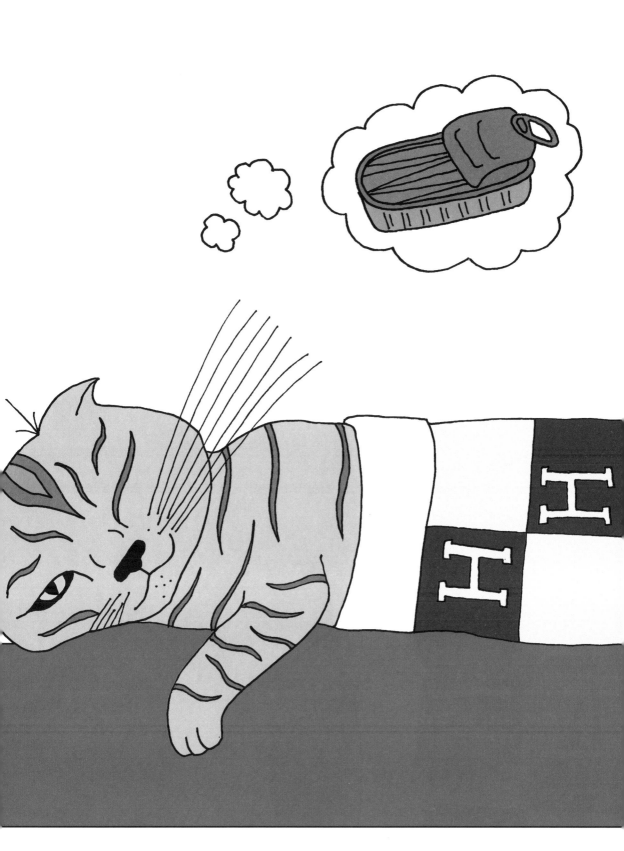

feel rather bad for the large handsome chap with the flattop haircut, who reminds me of an '80s action star; my trailer is twice the size of his. He is called Argylle, which obviously means he thinks he leads this film. All rather awkward.

I don't want to be the one to tell him that names aside, the size of one's trailer usually dictates who is top dog.

I've leapt down from mine (panther-like) to find him waiting for me. We're twinning this scene. I of course don't flinch, but he's a bundle of nerves, bless him. I still think everyone is getting used to my presence on set. I play nice, let him pick me up and stroke me. It's always the big boys who are the real softies…

I, however, really need to visit the loo. Argylle is more than happy to spend the next few hours perfecting his Blue Steel on camera, but I've got to get my arse to the litter tray.

uick call with my agent; they've failed to deliver my rider (platter of anchovies and sardines with hollandaise sauce). I'm assured someone is on it, sharpish. Let's see if that runner can in fact run…

Filming is slightly behind schedule, so a lovely woman called Elly Conway has kindly invited me to her trailer for lunch. I recognise her name, it feels familiar…

She's more than charming and understands what makes us felines purr. Lots of stroking and kisses. I try very hard to stay in character, but four dragon sushi rolls and a whiskey sour later, I quickly find myself slipping back into Chip! I'm spilling all the gossip like it's no one's business.

30 APRIL

My first actual shoot and it's under the lights. The atmosphere is electric. Just like a Champions League match. Before I grace the cameras, a private vet wants to give me the once-over to check my vitals are all behaving correctly. Something about insurance purposes. I'm no diva and so I oblige; he takes my blood, checks my heart, asks me to yawn and scratches my stomach – all very painless. He remarks how stable my blood pressure is, given the circumstances. I remind him who he is addressing. This kitty is one cool cat…

Golf buggy to set where I'm shown where to stand by the AD. X marks the spot. Lots of bodies huddled around the camera. Someone touches my fur, holds a reader in front of my face. A boom is lowered, and the board claps shut. Action!

I'm giving it cattitude.

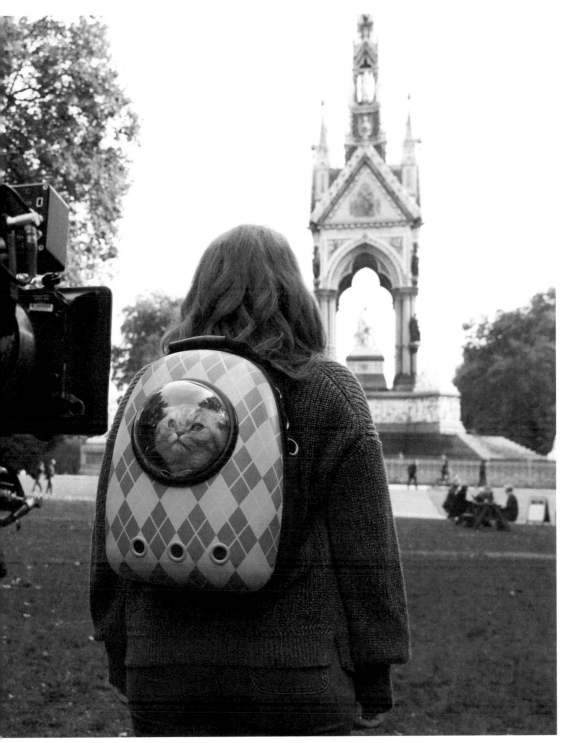

Living in a bubble: the glamorous side to Hollywood.

A star pawformance.

1 MAY

Well, what can I say – I'm a natural. The camera loves me, and I love the camera. We're the perfect match. The scene was a triumph. The way I held my pose, flinched my whiskers, and smashed the fourth wall. You'd be forgiven for thinking I had done this all my life. A standing ovation as I left the set. And to think they were genuinely considering Smartie for the role. Ha! I stay humble and take the time to walk around set, thanking everyone for their work, and happy to receive congratulations on mine. It's important not to forget the worker bees who make this all possible. I hear someone yelling my name... That's my cue to dash off. A much-deserved week off starts tomorrow...

3 MAY, HOME

Eurgh, can barely move. Rigor mortis has seized my limbs. Claudia has roped me into her pre-Met Gala fitness regime, which means waving goodbye to civilised living. This was supposed to be a week off! I'm wrenched from slumber each morning at 6 am and forced to do Pilates followed by 5K on a treadmill. 5K! I'm a cat, not a horse in feudal times. There's enough equipment in this gym to train a small army. Dante would have added circuit training to one of his circles of hell. To top it all off, we're only allowed chia seeds and blueberries for breakfast. I'm craving a deep-fried kipper…

That's enough for one day.

You shall go to the ball!

It's Met Gala night, baby! We hopped across the pond a few days back, and I've shaken off the worst of the jet lag. Champagne is the only remedy for that. Claudia and I are blaring out the tunes in our hotel suite as we get ready, *Ooooh Heaven is a Place on Earth* – and Belinda was right, we're living proof. These outfits are simply divine.

Limo to the red carpet, where we are bathed in light. The cameras can't get enough of me. Claudia scoops me up as we swan down the press line, posing together down the track. All the gang are here, new and old. You can't move for all the stars. There are lots of compliments coming our way for these outfits, particularly from America's most famous family, those Kool Kats... I can't keep up! I'm getting lost in all the curves...

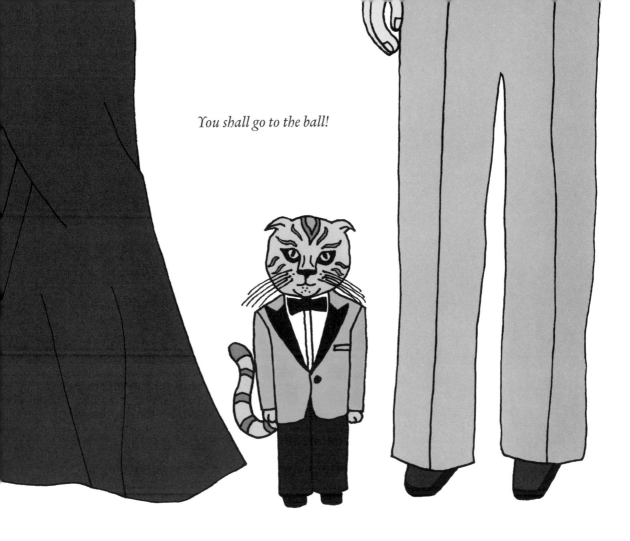

You shall go to the ball!

Inside, the Met have made sure we're on the best table.
A rather famous Gucci muse and singer to my right, is only
looking in one direction. Unfortunately, it's not mine, so I leap
between his legs and give him quite the surprise! Right, who
can give me a treat? Or even better, another part in a movie?

7 MAY

No biggie, but I'm trending on TikTok
following last night's appearance.

#HotMessChip

Nine lives are not enough.

Back on set and today is a big shoot – an action sequence where I am running across the London skyline before jumping into the Thames. The AD wants to know if I'm happy to do my own stunts. I mean, really. I backflip for treats; of course I'm doing my own stunts. The insurance company are against it: apparently, I'm too valuable to run the risk of injury. But they knew my value before, that is why I came on board: to lend some profile to this picture. The other option is getting a stuffed double to stand in my place. What is this, Tussauds? I tell them to sort it with my agent. I head back to the trailer for a massage and a kip.

Insurance company assuaged. The shoot is going ahead. I'm carried up to the roof. A Steadicam will follow me, all I have to do is run and jump… Beginning to have second thoughts now. It really is quite high… I pull the stunt co-ordinator aside for a private word. We'll re-group in the morning… Shooting to stop for the day.

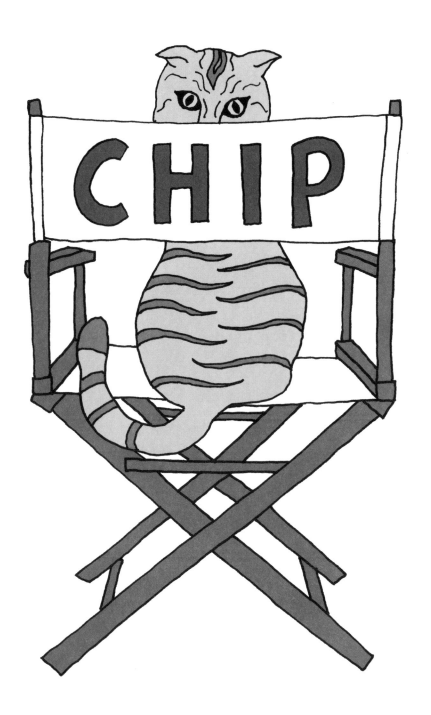

13 MAY

More calls with my agent and the insurance company. Thinking on it more, it seems like a mad idea – what if something were to happen? Who could possibly take my place? The whole film would be in jeopardy… No, it's been decided. Bring out the double.

16 MAY

Exciting day ahead; a two-hander with a rather bedraggled man called Aidan. He needs a shower and a haircut. Action! And we begin. It's an intimate scene, lots of physical and eye contact. We do a few takes, but it's immediately apparent that, fair to say, Aidan and I aren't clicking. He's flinching at every turn. He's obviously nervous to be acting in my presence, anyone would be, but come on – time is money! First AD calls for a timeout. Apparently, Aidan is bleeding.

On set. The cat's out of the bag.

Now waiting to be summoned from the trailer, but before you can say pussy, three men with walkie talkies are pinning me down and trying to wrestle the nails from my paws. Do these beasts know what a pedicure is? The whole episode is rather traumatic if truth be told. How am I going to scratch my itches now?

18 MAY

We're going to re-shoot the scene with Aidan. They've brought an intimacy coach on set. Apparently, my claws were too sharp. Honestly, he could have asked me nicely to give them a file, rather than bitching to the SWAT team…

We get the scene in two, which means I'm free to do press interviews for the rest of the afternoon. The usual patter for YouTube and TikTok; 73 Questions with Vogue, a brief appearance on *Kermode and Mayo's Take*, and Adam Buxton finally gets to chat with a real-life pod cat…

Scaredy cat.

air and makeup followed by kippers on toasted rye bread. Today I'm quite nervous, let me tell you. I just saw a glimpse of gold as a beautiful woman in a thigh-split dress sailed past my trailer. I know immediately, VERSACE.

A scent of… danger?! Oh, that perfume is intoxicating – I'm practically levitating. It's hard to explain, but everything about this woman screams trouble. Apparently she is called Legrange, and I simply have to meet her.

Fate intervenes again. I am meeting this Legrange in an hour. Just us. Oh great Bastet, thank you. Where is that runner? I need a drink…

<div align="center">***</div>

Well, I am shaken to my core. I'm marching to the producers' trailer right now. Turns out the 'tête-à-tête' involved a motorbike, a machine gun and a fur-raising car chase across some rooftops. I never want to see Legrange again.

Kind of awkward catching up with Smartie and Rollo again – they say they don't know who I am. I archly tell them they never did. Some people just can't stand change. Some people just don't want to see others succeed.

I caught myself in the mirror this evening. It's the first time I've been without makeup in weeks. My face has changed: I'm older, wiser, more mature – oooh there's a ball of string…

21 MAY

They're shooting on location in Deptford, which I'm more than happy to send my stunt double along to – this cat doesn't shoot anywhere outside Zone 1. Claudia is beside herself to have me home. Smartie less so.

Claudia is pulling out all the stops; trips to Daylesford, full-body tickles, and a little something to welcome me home – an *Argylle* collar which makes my eyes just sing. God I've missed her. That evening we gorge on takeaway from Nobu and retro-binge *Sex and the City*. Utter heaven.

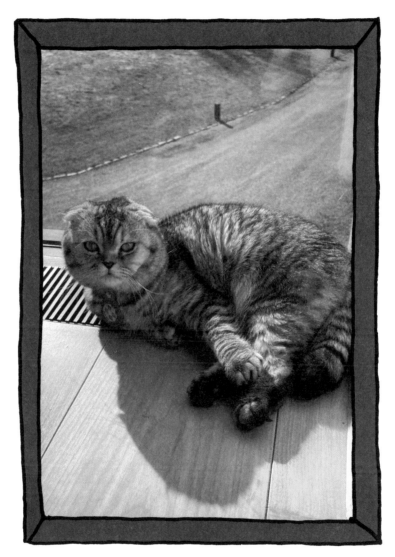

The camera loves me.

spend the afternoon practising my lines in front of the camera, on the Colorama roll left over from a recent at-home shoot, and helpfully began signing copies of Claudia's book *Captivate!* with my soon-to-be-famous paw print. I was sent away with yells before I could sign them all. I was only trying to help. Sad!

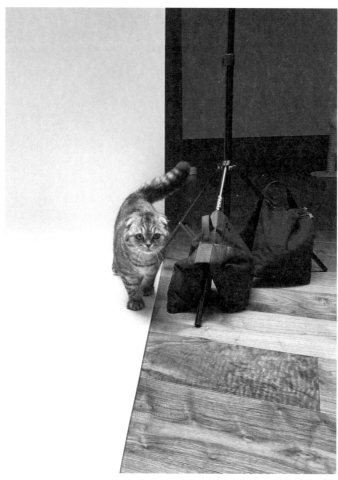

My catwalk.

How time flies. The camera calls for the last time, and I'm feeling more than emotional. The scene is a tricky one. For some reason we can't get it quite right. Rest assured it's nothing to do with my performance (how could it), but the whole film hinges on this moment, so it must be perfect.

The crew re-groups and we shoot again, but something is still missing. The light is about to fade. We take our positions, and the board claps again. I take the leap and go off script. I'm spitballing, freewheeling, but it feels so right. I am no longer Chip; in this moment I *am* Alfie. I am all leaps and claws and facial expressions. I am marvellous.

I hear "Cut!" and the spell is broken. For a moment there is silence. A stunned silence. I don't know where to look. Then the set bursts into applause. We've got it! We've got the scene.
Tears begin to stream…

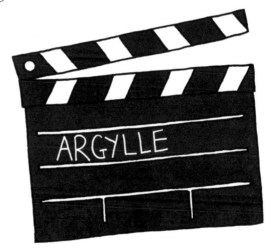

And that's a wrap. Which means one thing: wrap party! But what to wear? I spend the afternoon prowling around Claudia's dressing room. The Saint Laurent 'Le Smoking' is chic. But I'm thinking something more daring, show off a bit of tail, give them something to chase. It is a wrap party after all … I've settled on a waistcoat by Miu Miu; it hugs my furry curves yet will allow me to throw some serious shapes. Argylle has gone for a fetching cashmere Kingsman Nehru jacket – all very on brand. Claudia is donning a spectacular Burberry number complete with lace, just purr-fect… We arrive at the Savoy and the place goes wild. I head straight for the canapés, where my *bouche* is well and truly amused. The cocktails don't stop as I hop from lap to lap, soaking up the compliments and anecdotes as I go. There's a toast in my name: *To Chip, the face that launched a thousand scripts*. The cast and crew descend on the dance floor, and we end on a high as the Best Boy hauls me on stage to lead everyone in a rendition of Al Stewart's 'The Year of the Cat'.

It really has been that.

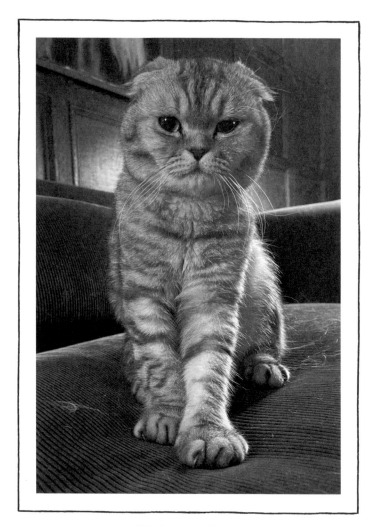

This is not goodbye.

EPILOGUE

Gosh, no matter how used one may get to seeing themselves on the big screen, it's always novel seeing your words on the page. I would be lying if I said I hadn't enjoyed re-reading these entries, marvelling at just how far I have come. But I'm still the same old cat. At least Claudia thinks I am...

Well, it's getting late, and I guess this is my stop. Don't cry now, it's not the final curtain – it's just an interval, a chance for us to powder our noses. I'm not done yet, not by any stretch of the imagination. In fact, I've only just begun.

Oh, what's this? Another script? This one doesn't look half bad...

Take care now and remember: if ever you need me, just call my agent.

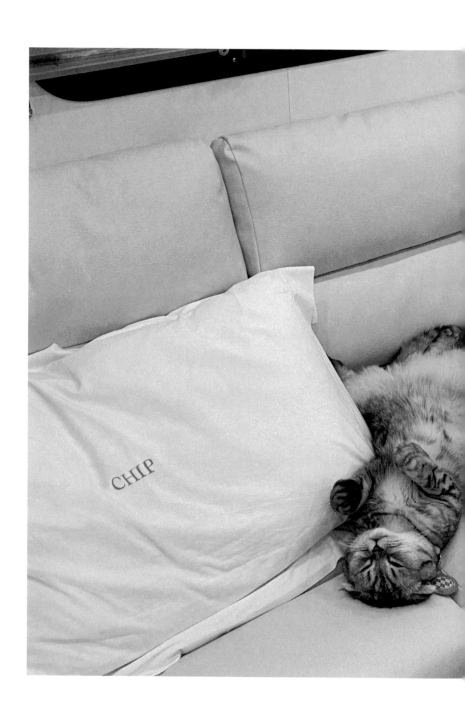

Getting into character.

GRATEFUL PURRS TO...

ANGELICA, LUCIE, ERIN, CARLOS,
OLIVER, ANNA, WILL, OLI,
DAN FROM COUPER STREET TYPE CO. AND
ROBERT, LARS AND MARTIN FROM GESTALTEN

IN ALPHABETICAL ORDER

• ALAÏA • ANNA SUI • BALMAIN •
• BARBIE • BATTERSEA DOGS AND
CATS HOME • BURBERRY • CALVIN KLEIN •
• CARTIER • CELINE • CHANEL •
• CHÂTEAU LAFITE ROTHSCHILD • CHELSEA •
• DIOR • DIPTYQUE • DOLCE & GABBANA •
• DAYLESFORD • DOM PÉRIGNON •
• FORTNUM & MASON • GUCCI • GUESS •
• HARRODS • HERMÈS • KINGSMAN • LIBERTY •
• LOUIS VUITTON • MARC JACOBS • McQUEEN •
• MIU MIU • MOKE INTERNATIONAL • MONCLER •
• PRADA • PROENZA SCHOULER • RALPH LAUREN •
• RICHARD QUINN • SAINT LAURENT •
• THE ROW • TOM FORD • VALENTINO •
• VOGUE • VERSACE • WILLIAMS RACING •

NO HUMANS WERE HARMED
DURING THE MAKING OF THIS BOOK

Published by gestalten, Berlin 2024. ISBN 978-3-96704-083-8. © Die Gestalten Verlag GmbH & Co. KG, Berlin 2024. Text and images © Marv Studios Limited 2024. ARGYLLE, MARV and the MARV logo are trademarks of Marv Studios Limited. Typefaces: MVB Verdigris Pro by Mark van Bronkhorst and Duper by Martin Wenzel. Printed by Offsetdruckerei Karl Grammlich GmbH, Pliezhausen. Made in Germany. All rights reserved. For more information, and to order books, please visit www.gestalten.com. Bibliographic information published by the Deutsche Nationalbibliothek. The Deutsche Nationalbibliothek lists this publication in the Deutsche Nationalbibliografie; detailed bibliographic data is available online at www.dnb.de. This book was printed on paper certified according to the standards of the FSC®.

MIX
Paper
FSC
www.fsc.org FSC® C011712